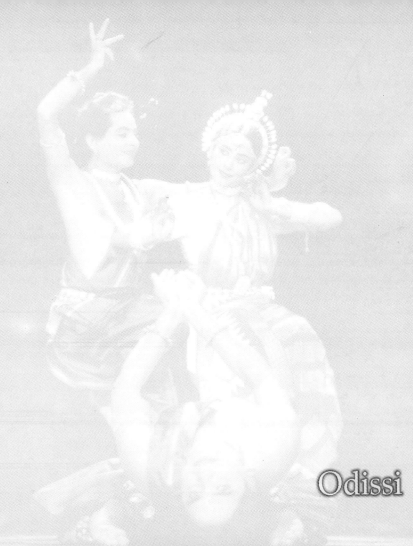

Odissi

wisdom
tree

Dances of India

Series Editor
ALKA RAGHUVANSHI

Photographs
AVINASH PASRICHA

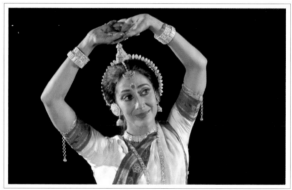

Odissi

Sharon Lowen

Copyright © 2004, Sharon Lowen
Photographs © Avinash Pasricha
Design: Kamal P Jammual

ISBN 81-86685-16-2

Published by

130411 1

Wisdom Tree
C-209/1 Mayapuri, Phase-II,
New Delhi-110 064.
Tel.: 28111720, 28114437

Printed at

Print Perfect,
New Delhi-110 064.

Contents

Origin and Development ... 11

Historical Development ... 15

20th Century Revival ... 27

Repertoire ... 41

Sahitya ... 57

Costume and Make-up ... 65

Technique ... 73

Music ... 91

Odissi Today and Tomorrow ... 97

Editor's note

The busy tolling of the temple bells, the throb of the pakhawaj, and the sonorous tinkling of the ghungroos of the mahari striking the stone floor in perfect rhythm, in tune with the song of Krishna's love Radha, the moment is eclectic and the mood electric....Who then can remain untouched?

I have always believed that seeing dance in its real habitat, the temple, is a far more uplifting experience than any concert platform. The energy of the temple situation unfolds a dimension that is a manifestation of the atman's desire to become one with the paramatman. Each step taken is a step in that direction. It is not

often however that one has the good fortune of having that experience. At least not of performers of a certain caliber. When the Odissi danseuse Sanjukta Panigrahi offered to dance for a certain period in the year in the Jagannath Temple in Puri, the temple authorities turned it down in no uncertain terms. What a pity. I can only imagine what an experience that would have been, if the dance of an aging mahari in the temple is any indication.

On the other hand, to Sanjukta's guru, Kelucharan Mohapatra goes the credit of reconstructing what is known as Odissi today from the ancient temple sculptures. He is to Odissi, what Birju Maharaj is to Kathak. Far apart in style and geographic locations, yet bound by the amazing creativity and completeness of their art. It seems only the other day that we saw both the maestros hugging each other with delightful warmth. Few eyes remained dry. It was indeed a special moment that will be treasured in the mind's eye for a long time.

Kelubabu has been guru to an entire generation of performers of today and Sharon too has drunk from the fount of knowledge and experience. Both Sharon and her guru-behn Sanjukta share more

than a guru. They share a grit and ability to survive without losing the inherent lasya and continuing to rejoice and celebrate life against all odds. Is it a precious lesson that they may have taken out of their guru's book? Kelubabu's quest has been fraught with many mountains he has had to climb.

Sharon brings to this text the love of a practitioner, the depth of an academician and the objective perspective of a transnational American, who has spent half her life in India. And when one sees instances like this, one's belief in reincarnation or previous connections becomes even more firm! What few people know is that she is also an accomplished photographer. For stylistic continuity we have been unable to use her gorgeous photographs on dance, but someday soon we will!

Alka Raghuvanshi

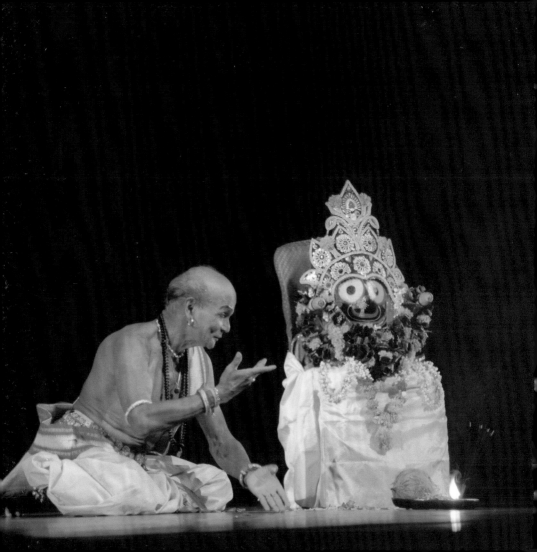

Origin and Development

O rissa, on the east coast of India, is known for its friezes embellished with graceful images in sculpturesque poses adorning the walls of its myriad temples. Odissi, the dance style from the region, is particularly known for its lyrical grace, elaborate rhythmic variations and dramatic expression. It is easily identified by visual manifestations of the silver ornaments worn by the female dancers to adorn their body and pith-flowers, topped by a prominent/elevated tiara made also of pith flowers and representing the spire of the temple also worn by these exponents to adorn their hair.

The earliest representation of this dance of Orissa is found on a 2nd

century B.C. relief sculpture of a dancer accompanied by musicians performing for a king. This on a wall of Rani-Gumpha at Udayagiri is the earliest extant performance-space or theatre. An inscription from King Kharavela at the Hathi-Gumpha states that dance was one of the entertainments he provided to his people. While the classical Odissi dance seen on the stage today may be far from the form seen by the king and his populace in 2nd century B.C., the roots of this performing art have their genesis from this time.

Odissi shares a number of essential characteristics with other classical dance forms of India, which are based on the principles outlined in the Natya Shastra. One of the most significant aspects of the dance is the balance between pure dance or nritta, i.e. dance that expresses movement to rhythm without a text based import, and the dramatically expressional dance or nritya, which is based on interpretation and variations of meaning from a text.

Perhaps the most significant shared aspect of Odissi to other classical Indian dance forms is the motivation of the dance from a spiritual consciousness. The metaphysical import of the dance in the past and

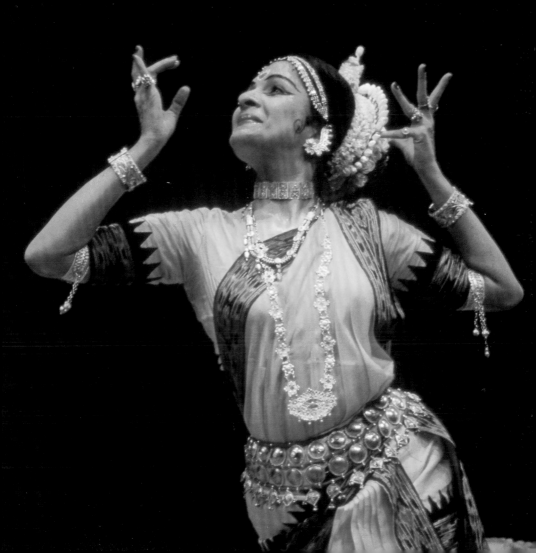

present is not limited to simple religious rituals, but aimed at a transformational experience for the audience and the viewer. How else could mokshya, or liberation from the cycle of birth and rebirth, have a place as the traditional concluding choreography of an Odissi performance? While the dance may entertain, it is not its highest goal. Yet, at the same time, the shift of location from temple to theatrical space allows the artiste and/or teacher to create performances emphasising various aspects of Odissi's technical and expressive vocabulary. While one artiste may choose to create an imaginary sacred space around the performance and offer the viewers a darshan, or sacred peek at the divine, another artiste can quite justifiably create a performance of sculptures moving in space and rhythm, virtually devoid of emotional or spiritual content, but aesthetically pleasing. The parameters of classical Odissi dance will continue to expand as the needs of the art dictate, as they have also done in the past. Classical dance is certainly not a static art form but continues to develop in form and content while, hopefully keeping its intrinsic character.

Historical Development

The Natya Shastra text on dance, drama and music ascribed to Bharata Muni, is perhaps the best known, definitive and detailed text on the pan-Indian performing arts, written sometime between the 2nd century B.C. and the 2nd century A.D. It speaks of the dance of Odhra Magadha, which included Kalinga and Odhra (modern Orissa), excelling in dramatic expression, that is, abhinaya. The relief sculptures of dancers and accompanying orchestra found on the walls of the Rani-Gumpha Sanskrit theatre predated the writing of this text, which is a comprehensive exposition on the well-developed performing arts of India.

Whatever was the continuity of dance over the next centuries as Buddhism flourished in eastern India, dance was sculpted in stone as seen on the majority of temples dedicated to Shiva from 7th century onwards. Shaivaite temples, like the 8th century Parasurameswar temple which abounds with virile dance poses of Shiva, were soon followed by other temples portraying him as Nataraja, lord of the dance.

The Parasurameswar temple (8th century) has a number of sculptures in postures of the tandava dance. Later temples such as the Vaital Deul, too have reliefs of Natraja. The early medieval temples like the Raja Rani temple have, on the outer walls, many dance figures that are illustrations of some very intricate movements described in the Natyashastra in a markedly local style. By the time of the Konarak temple, the style had been set and a very distinctive method of body manipulation is apparent.

Legend has it that two of the Kesari kings, whose Kesari dynasty lasted 300 years starting from 9th century, were called Nritya Kesari and Gandharva Kesari for their expertise in dance and music.

Buddhism declined and Brahmanism grew stronger by the end of the Kesari rule. The great ruler Chodagangadeva of the Ganga dynasty (1077-1147) was responsible for building the magnificent temple dedicated to Lord Jagannath at Puri and initiating the tradition of having dance as part of the temple ritual. In 1194, King Anagabhimadeva added the hall of dance, or natamandira, to the temple. During his rule, a number of temples were built. The king patronised Maheswara Mahapatra, who authored the Abhinaya Chandrika, generally considered to be the foremost text on Odissi dance, and poet Jayadeva, who wrote his masterpiece the Gita Govinda, or the song of Krishna. The last Ganga ruler appointed musicians and 20 dancers to serve in the Puri temple.

The increasing emergence of early medieval devotion to Vishnu was reflected in a profusion of temples all over Orissa, with dance sculptures echoing the detailed descriptions written/codified in the Natya Shastra. Traces of Buddhist, Shaivaite and tantric forms of worship were assimilated into the conception of Lord Jagannath. Jagannath is identified with Krishna-Vasudeva, yet is also viewed as Buddha, Shiva and, even, Bhairava. This blending of disparate

disciplines was a distinguishing feature of medieval Vaishnavism. From the 12th century onwards, Lord Jagannath was exclusively considered a Vaishnavite deity, though tantric rituals were incorporated in the worship.

In 1435, the scholarly Kapilendra established the Solar dynasty. He built the outer wall of Jagannath temple and had inscriptions carved on the temple walls, including an order for the performance of a dance offering in the natamandira at the time of the bhog (or mid-day meal) of Lord Jagannath and again in the evening as the god was ritually adorned for bedtime and which was called bada-singara, or barha-sringara. Besides dancing, Kapilendra also introduced the singing of Jayadeva's Gita Govinda to the temple ritual.

This was the era when Lord Jagannath became firmly established as the state-deity of Orissa and when the importance of Radha as the special gopi in the worship of Krishna/Jagannath through dances and songs from the Gita Govinda was initiated. The idea of one particular gopi, Radha, standing out from all the others became central during the Chaitanya era from 16th century onward, but was the nucleus

of the Gita Govinda's theme. The Gita Govinda became popular throughout India for dance and dance-dramas, as did vocal offerings by those devoted to the flute-playing Lord Krishna. Radha's love for Krishna is generally considered a metaphor for the soul's love for union with the divine. The emphasis is on anticipation and yearning for union expressed in a rainbow of emotional nuances through many beautiful and evocative poems, with the fulfillment of union treated relatively briefly in the text. In the Jagannath temple, only the poetry of Jayadeva was permitted to be offered in the sanctum by singers or dancers. The passion of bhakti, or devotion, was articulated with sophistication in the aesthetics of music and dance.

And who were the dancers? Since the 9th century onwards, there flourished the tradition of young women dedicated to service in the temples, offering dance and song to the deity, primarily to Shiva and increasingly to Krishna/Vishnu/Jagannath.

Maharis, Devadasis — Female Servants of the Lord

These dancers, who lived as servants of the deity, supported by temple funds, were called maharis. They were also connected

to palace rituals and to the king, who was considered the living incarnation of their divine husband. They did not marry as they were considered married to the deity of the temple. Scholar Frederique Marglin has made the important observation that these temple dancers, as they could never be widowed, maintained the auspiciousness of Hindu married women throughout their lives. They were regarded as harbingers of good luck at any royal or Brahmin function. The mahari has a certain power over Krishna-Jagannath through the latter's dependence on her for providing pleasure to Him through her service, according to the form of Vaisnavism practised.

An insight into the duties of maharis in earlier times is written in a royal proclamation in the possession of Sadashiv Rath Sharma, when he was attached to the Historical Research Department of the Jagannath temple: "Maharis are forbidden to enjoy the company of men. They are to dance only for ceremonies and festivals connected with Lord Jagannath. After initiation, they are always to adorn themselves with the mark of the tilak, and they are also to wear the tulsi-kanthi necklace of basil leaves. They are not to partake of food prepared at home. They are to wear clean clothes. On the days on

which they have to dance, they are not to speak to any man. They are to be conducted to the temple by the mina nahak. At the time of performance, they are not to look at the audience. Their dance must strictly follow the shastras. They must dance in perfect co-ordination with the singers and in the following talas: Pahapata, Sariman, Parameshwar, Malashree, Harachandi, Chandan Jhoola, Shreemangala Bachanika and Jhuti Ath-tali. They are to perform bhava only for songs from the Gita Govinda." In short, the mahari should maintain strict ritual purity.

Bahar-ganj (outer sanctum) maharis danced in the temple at the time of bhog, or the mid-day meal, of Lord Jagannath and performed in the special performance area, the natamandira or nata mandapa. In recent times, they began to use the audience hall adjoining the sanctum. Bheetar-gane (inner sanctum) maharis performed after the evening meal and before Lord Jagannath's ritual adornment before bedtime. A vocalist, percussionist and musician keeping rhythm with small cymbals, or gini, always accompanied the dance, with additional musicians, at times. This is the same model for accompaniment of classical Odissi today.

Besides the two traditional ritual dances each day, the maharis played an important role in performing during approximately 10 annual festivals, especially chandan jatra, a procession during the spring season of Baisakh, and jhoolan jatra, in the monsoon season (Shravan). During chandan jatra, the image of Jagannath is shown to float on a small boat in a sandalwood scented tank of water, three miles from the temple. A boat each of mahari and gotipua or boy dancers alternately sing and dance to entertain Lord Jagannath. Both groups also entertain the Lord during the festival of jhoolan (swing) jatra and these rituals are performed at other Vaishnava temples of Orissa as well.

In the first half of the 16th century, the Bengali saint Chaitanya settled in Orissa and transformed the Vaishnavite form of worship of Krishna. The centrality of Radha was expressed in the Gita Govinda when it was performed for Lord Jagannath at the daily bada-sringara ritual ceremony, but it was Chaitanya who spread the Radha idea to the populace. Chaitanya's followers considered him the incarnation of both Radha and Krishna, but he imitated Radha as the soul descended to earth and as the embodiment of separation from Krishna

(vipralambha vigraha). Chaitanya's love for the Gita Govinda led to the sainthood of poet Jayadeva within the Vaishnava Sahajiya cult that complements the 700-year old Oriya tradition of the Gita Govinda's importance in the rituals of Lord Jagannath in Puri.

Raja Prataprudra met Chaitanya in 1512-13 and was receptive to the Chaitanya movement in Orissa, which necessitated adjustment in the older forms of worship. The Raja's governor of Rajmahendri, Ramananda Pattanayak, better known as Ramananda Raya or Rai, was a poet and musician who resigned his office to become the foremost Oriya devotee of Chaitanya's Gaudya School of Vaisnavism. He was instrumental in developing the dramatic expression, or abhinaya of the maharis. He wrote the opera Jagannath Ballav, a minor Sanskrit classic and used maharis in dance-dramas that had formerly been the sole preserve of men and boys. This marked the beginning of efflorescence in the expressive development of the dance of the maharis.

Gotipua Dance
The neo-Vaisnavism of the Chaitanya era created the right environment

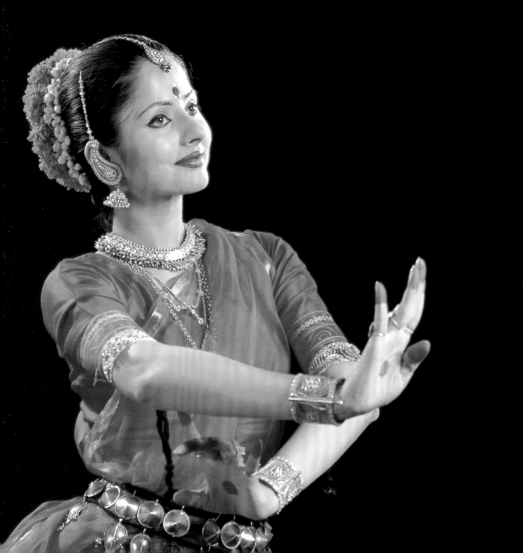

for dance to become a vehicle of expression to reach the people. The custom of having Odissi performed by boys dressed as girls enabled the devotional poetry to reach the general public outside the temple precincts. It was also a logical development, both because women dancing in public was not acceptable during that era, and secondly, because sakhi bhava or worshipping Krishna as female devotees was an acceptable religious practice. The Bhoi king, Ramachandra Deva, was the ruler during this time and he allotted a street near the temple to the gotipuas. Gotipuas were the boy dancers who begin training at the age of seven and generally end their dancing career by the time they reach 18. He also established akhadas, or gymnasia, for professional training. The gotipuas performed at religious festivals, social gatherings and occasionally in temple courtyards, and had considerable patronage till the 19th century.

The most interesting and unique part of the gotipua performance is the acrobatic Bandha Nrutya.This is still very much part of the gotipua repertoire though not included in the classical Odissi dance performed on stages today. It is described in the 15th century Abhinaya Chandrika by Maheswar Mohapatra as a difficult and painful form of

dance, possible only during adolescence. The book lists 10 varieties of bandhas and some of the poses are among the acrobatic karanas or dance phrases, found in Bharata's Natya Shastra.

By the end of the 19th century, the gotipua dance was apparently influenced by what was considered a more decadent dance, Sakhi Nach, performed on Orissa's southern border. However, the Oriya texts and the music and training of gotipuas have provided a strong base for the revival of Odissi dance in the 20th century.

20th Century Revival

The revival of classical Indian dance in the 20th century was concurrent to the rising aspirations for an Indian national identity that culminated in India's Independence from colonial rule. As the English educated intelligentsia increasingly questioned the Victorian perspective of India's cultural heritage and other indigenous identities, rediscovery of its artistic heritage was an integral part of a renaissance of national self-discovery. The British equation with prostitution of all forms of dance activity, whether in temples, public places or kothas, resulted in the draconian Anti-nautch Dance Acts, starting first in the Madras state of yore.

At the time the Western ballerina Anna Pavlova toured India in

the 1920s, her requests to see authentic Indian dance fell on embarrassed or ignorant ears. Those who had seen Indian dance had generally seen a variation of nautch dance at private gatherings, which they were reluctant to admit having seen, when among polite society. Anna Pavlova was personally responsible for turning both Rukmini Devi and Uday Shankar's interest away from learning Western ballet to a search for their cultural heritage in dance. This exciting renaissance is well documented, but the circumstances of recognition for various dance genres around the country had as much to do with the efforts of particular individuals in various regions, as it did with the great traditions themselves. E.Krishna Iyer and Rukmini Devi Arundale were warriors for Bharatanatyam; poet Vallatol created the Kerala Kalamandalam for Kathakali; and Rabindranath Tagore used Manipuri as the base for creating his dance-dramas.

By the time India won her Independence in 1947, four classical Indian dance forms were recognised: Manipuri, Kathakali, Kathak and Bharatanatyam. Odissi was added to this list as the fifth style in 1958. Odissi was recognised in 1958 by the Sangeet Natak Akademi,

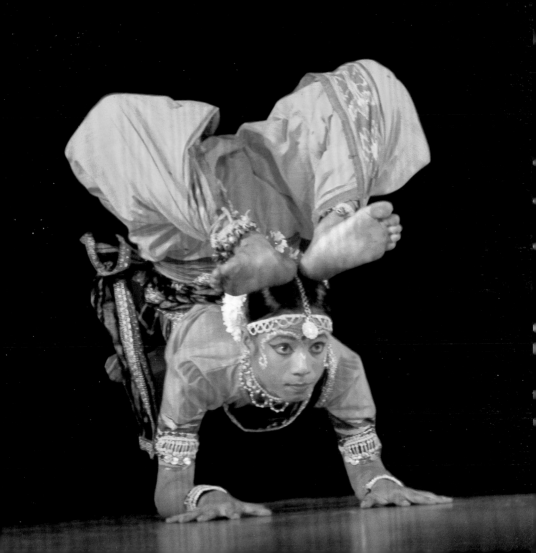

the national performing arts body of the government, in New Delhi. This official recognition came about over a period of several years through the efforts of scholars and gurus to present Odissi outside the state, as well as 'Sanskritising' and codifying Odissi in terms of the classical Sanskrit texts, so that it could be seen to fit into a pan-Indian classical mould. This process both stimulated the continuing refinement and development of the art while at the same time discouraging some of the tribal and folk elements that seemed outside the Natya Shastra mould.

The 20th century revival of Odissi drew on what remained at low ebb of centuries of rising and falling fortunes in the development of the dance, both within and outside the temple. The ancient mahari tradition, with its emphasis on dramatic expression, and the medieval gotipua tradition of boy dancers performing outside the temple precincts, which emphasised the more physical and even acrobatic aspects of the dance, constituted the foundation for development of classical Odissi as we know it today. Considerable research and inspiration from temple sculptures, Patachitra paintings and written

texts fuelled the development. About 50 years ago, there were still 30 devadasis or maharis in Puri. About 30 years later, there were only nine and fewer still participated in temple rituals. While daughters of devadasis rarely married in the past, all the daughters of the last generation of devadasis have married and this marks the end of the tradition.

Several years ago, dancer Sanjukta Panigrahi volunteered to perform the daily ritual dances for Lord Jagannath in the Puri temple for one to two months in a year and suggested to the temple authorities that other dancers could perform the rituals, by turn, during the rest of the time. Her offer came from a great desire to return her spiritually motivated art from the stage to the temple. If the classical dance arises from a spiritual consciousness, and this is the supreme aim of a performing artiste in a theatrical space, it is logical to wish to make that offering in the temple sanctum itself.

The priests of the temple refused, as her married status placed her outside their definition of a devadasi who could offer dance for the deity, even though this decision ended the possibility of continuing

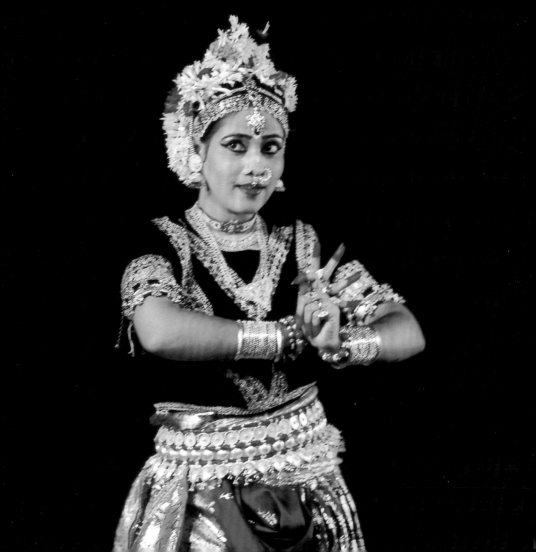

dance as part of the temple ritual. It was interesting to note that a significant section of public opinion was outraged by the suggestion and they saw Sanjukta's offer to perform the dance ritual only as socially retrograde support for prostitution, rather than a sincere and logical desire by Sanjukta to support the religious institution that inspired her dance.

The fact that dedicating young girls to the temples of South India is still misused as a cloak for prostitution, need not tar all female temple servants with the same brush. Frederique Marglin has clearly established that the maharis of Puri's inner sanctum may not have been chaste, but they were not prostitutes, though their connection to a particular Brahmin temple servant or the king would have been seen as morally degenerate by the Victorian standards of the early 20th century revivalists.

Of all contemporary Odissi gurus, Pankaj Charan Das was the closest to the mahari tradition because he grew up in a mahari family in Puri and learnt dance from his aunt, Ratna Prabha Devi. Other senior gurus of Odissi had early training in the gotipua tradition. However,

all gurus, who contributed to the development of the classical Odissi that we see on the stage today, evolved their art through the crucible of years of work on the Jatra folk theatre stage of Orissa. Gotipua dance had reached a low point in the early 20th century. No Gotipua gurus played a significant role in the renaissance of Odissi as a classical dance for the stage. Every one of the pioneer generation of gurus in the mid 20th century had considerable theatre experience after training in the gotipua tradition.

Many individuals, including the father of Guru Kelucharan Mohapatra, considered it a vulgar dance of the market place. Kelucharan Mohapatra's story is an excellent mirror of the development of Odissi, particularly as he is a central figure in its revival. Kelubabu, a respectful Oriya nickname for Guru Kelucharan Mohapatra, grew up in Raghurjpur, a village of skilled painters and sculptors, near Puri. His father was an accomplished traditional pata chitrakara, or visual artist, who played mrudang as an accompaniment in temple festivals. There were two village akhadas, or gymnasia, training gotipua boy dancers in this village. There is still a gotipua troupe in existence there. Child

Kelucharan secretly joined classes for three years during his father's afternoon siesta. When Balabhadra Sahu, the teacher, felt his student was ready to have his ears pierced and give his first performance during Devi Puja, Kelubabu's father's response was to send him to a respected Ras-Leela traditional theatre company to gain a finer theatrical training. Backstage training, learning to play the pakhawaj and tabla, along with small roles and a bit of dancing, was exactly the kind of foundation needed to participate in the neo-classical revival of Odissi for the concert stage in the coming decades.

Guru Pankaj Charan Das was already with the Annapurna 'B' Theatre in Cuttack, including dance as a prelude or in the drama in every production. When Kelubabu joined from 1946 to 1952, his talents as dancer and choreographer flourished. Laxmipriya was brought from Annapurna 'A' Theatre in Puri to become the first woman to appear on the Oriya stage playing Mohini. She eventually married Kelucharan. The duo became famous for their duet of Dasa Avatar.

The dance in Orissa used mudras or hasta abhinaya (hand expressions)

following the Oriya oral tradition of teacher to student, guru-shishya parampara, but direct study of ancient texts for developing the technique and tradition was yet to come. Guru Dayal Sharan taught Uday Shankar training techniques and introduced the usage of Shastric mudras for the Annapurna Theatre. Familiarity with Shastric hasta abhinaya enabled Kelubabu to later discover the neglected aspects of the expressive gestural language of the mudras of Orissa. Over the years to come, he delved into the forgotten texts of Orissa, visual depictions on temples and the classical Sanskrit texts on dance, Abhinaya Darpana and Natya Shastra. His young students Sanjukta Panigrahi and Minati Misra introduced these texts to him in the late 1940s and early '50s in their summer holidays from Rukmini Devi's school, Kalakshetra, near Madras, for teaching Bharatanatyam, the reconstructed classical dance of Tamil Nadu.

This was a time of ferment in the arts as well for the new nation. By 1950, dance had played an essential part in the burgeoning theatre movement in Orissa. Daughters of progressive families were starting to take private tuitions in dance at home. The need and possibility

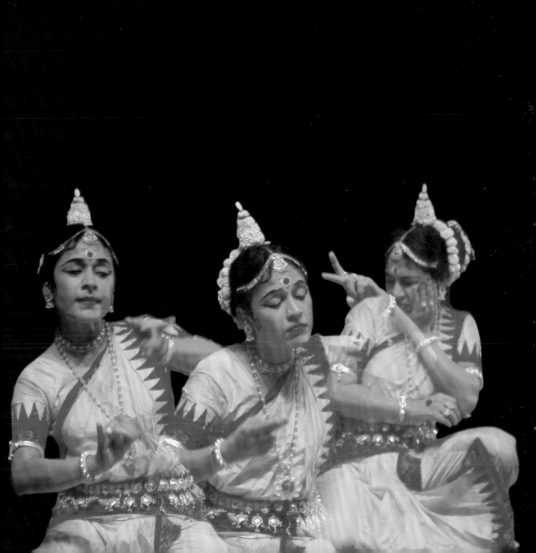

of bringing Odissi to the concert stage with independent dance performances demanded major reconstruction and research.

This was the decade when Odissi shifted from being viewed as a regional offshoot of south Indian forms to recognition as a major classical dance genre in its own style.

Kala Vikash Kendra at Cuttack was the first institution of dance and music to offer Odissi. Guru Kelucharan Mohapatra shifted completely from theatre to dance teaching and choreography in joining. Guru Mayadhar Raut also taught at the Kala Vikash Kendra, Cuttack, which encouraged his studies at Kalakshetra to enrich Odissi's reconstruction. Leading Odissi dance gurus, Pankaj Charan Das, Deb Prasad Das, Kelucharan Mohapatra, Mayadhar Rout, along with Raghunath Dutta, Dayanidhi Das, and scholars D N Pattanaik and Jiwan Pani met over three months in 1957 as the seminal Jayantika group, to try to agree on fundamental rules of Odissi in its revival.

Re-discovering classical Indian dance forms helped unify a sense of Indian shared traditions around independence and sharing these art

forms throughout the country has played a vital role in national integration. Today some of the finest exponents of Odissi dance are born outside the state and there is a constant cross fertilisation between artists and gurus from Orissa as the art continues to develop.

Deba Prasad Das's disciple, Guru Durga Charan Ranbir is in the forefront of developing his guru's style with vitality. There is vibrancy in the form that is refreshing and adds to the range of repertoire seen on the concert stage. This style is also furthered through the teaching, choreography and performance of Guru Gajendra Kumar Panda and the Sutra Dance Theatre under the direction of the Malaysian artiste, Ramli Ibrahim. Pankaj Charan Das has left an indelible mark on the elegance of style and repertoire of Odissi.

Guru Mayadhar Raut played a major role in introducing Sancharis, or elaborations of the danced text, to the modern repertoire of Odissi after his Kala Vikash Kendra supported study at Kalakshetra. He is a leading guru of Delhi with a number of disciples performing professionally. Guru Surendranath Jena has developed a unique style of Odissi that focuses on the Alasa, or soft lassitude, aspect of Odissi,

which has a small but significant following outside of Orissa. Guru Gangadhar Pradhan is one of the most dynamic "second generation" gurus, with disciples around the world, whose teaching and choreography reflects individuality honed on training by Kelubabu as well as Pankajbabu and Debababu. While Guru Kelucharan Mohapatra continues as a towering creative force at his institution Srijan, headed by son Ratikant Mohapatra, many disciples are maintaining and moving the tradition forward through their own teaching. The Odissi Research Centre, under the direction of KumKum Mohanty, conducts research and documentation of Odissi dance and music while training students and creating new repertoire. Protima Gauri Bedi's Nrityagram village centre for dance near Bangalore, carries on with dancer/choreographers Surupa Sen and Bijayini Satpathy under the direction of Lynn Fernandes. Innovative choreographers and teachers around the country include Sharmila Biswas in Kolkata, Jhelum Paranjape in Mumbai and Padmavibhushan Sonal Mansingh in Delhi.

Repertoire

About 60 years ago, an Odissi performance could be completed within half an hour. The entire repertoire was continuous as one composition, with dramatic expression and pure dance sandwiched between the opening invocations to the earth and the heavens and the concluding mokshya.

In Odissi's revival during the last century, this continuity was separated into discreet components. A group of gurus and scholars of Odissi came together in 1957 to form a group, Jayantika, to systematise the Odissi dance form and decided that the repertoire would consist of mangalacharan, batu nritya, pallavi, abhinaya and mokshya.

This motivated group included Pankaj Charan Das, Kelucharan Mohapatra, Deba Prasad Das, Raghunath Dutta, Mayadhar Rout, Dayanidhi Das and scholar D N Patnaik. While the Jayantika group dissolved after two years, owing to some unresolved opinions on technique and repertoire, it succeeded greatly in furthering the development of Odissi as a classical dance form.

The elements of the repertoire were expanded and new dances in each genre were choreographed. While all the gurus have enriched Odissi immeasurably, Guru Kelucharan Mohapatra has come to be known as the architect of Odissi over the last 50 years, with over 50 group productions to his credit and hundreds of solo compositions. With brilliant music composers like Balakrishna Das and Bhubaneswar Misra to assist him, Kelubabu drew on his knowledge of dance, traditional Oriya painting and temple sculpture, mastery of the pakhawaj, and years of theatre work to create a repertoire of solo and group choreographies for the stage.

Starting from a gotipua repertoire that was stretched to last 30 minutes, Kelubabu took the few-minutes-long pallavi structure of

theme and variations of raga, taala, and nritta, or pure dance movement, and systematically evolved pallavis in ragas Vasanta, Shankaravarana, Kalyani, Mohana, Saveri and Arabhi and later in Bihag, Hamsadhwani, ragamalikas and more. Guru Pankaj Choran Das's early Vasanta pallavi composition was seminal in initiating this process.

As any other Indian classical form, dance in Orissa is divided into pure dance and expressional dance, nritta and abhinaya (nritya/natya). The major distinction between pure dance and expressional dance is whether or not it is performed accompanied by a text. A pure dance will have a basic mood that is expressed through movement, but an abhinaya, or dramatically expressional dance will interpret and often develop a text.

The repertoire described here is the core format outlined almost half a century ago by the Jayantika group. It could be performed in a minimum of 45 minutes with the simplest, shortest choreographies and texts, but typically, a complete performance will take approximately two hours. The exigencies of today's performance venues, audience requirements and other special circumstances necessitate changes

in the traditional format times. The practice of eliminating batu nrutya or sthai is the most frequent casualty. At times, the invocatory item may be substituted with either a simple pushpanjali, or flower offering, or the bhoomi pranam, obeisance to mother earth, before a central item of pallavi or abhinaya. New choreography may even combine all the elements of the repertoire in an inclusive presentation with textual interpretation and pure dance woven together.

Mangalacharan

The Natya Shastra states that the difference between sacred and profane dance is determined by whether the performance begins with an invocation to the gods. In the current classical Odissi performance sequence, the opening invocatory dance is called mangalacharan. Typically, the dancer enters, often carrying flowers, and proceeds to the centre of the stage to begin the invocation. If the image of Lord Jagannath is placed on the front left corner of the stage, the dancer may go first to offer a prayer to this Orissan representation of the Lord of Universe. Alternatively, the dancer can begin with bhoomi pranam. This respectful greeting to mother earth is both an apology for stamping on the earth and appreciation

for her support. The bhoomi pranam is executed entirely on rhythmic syllables with only percussion accompaniment. Mangalacharan is continued with an invocation accompanying a short text, often Sanskrit shlokas or other stanzas in praise of Ganesh, Saraswati, Vishnu or any other deity appropriate to the occasion or milieu of the performance. Invocations to Ganesh, as the remover of obstacles, are the favourite invocations, particularly Namami Vignarajan and Pade Vande. This invocatory number, also called Bighnaraja puja in Orissa, is dedicated to Ganesha, with a prayer for auspicious beginnings with a shloka or may be performed to purely percussive rhythm.

Saraswati, the goddess of music and learning, is also frequently the focus of an opening descriptive praise, as in the traditional manikya veena mangalacharan. Following the invocation, mangalacharan is continued with the hands in anjali, joined in front of the heart in the traditional position of greeting. This accompanies movement covering the stage space in greeting to the audience, the eight directions and concludes with trikhandi pranam, hands held aloft to the gods, in front of the head to the guru or the teacher and in front of the heart to the rasikas or the distinguished audience. After the obeisance has

been paid to mother earth, deity and audience, a traditional performance continues with batu nrutya or sthai.

Guru Pankaj Charan Das did not accept mangalacharan as the opening of a performance for the stage as his dance background reflected the mahari temple-dance tradition and he felt that mangalacharan should only be performed in the temple because of tantric connections. Instead, Pankaj Babu's stage performance repertoire opens with the dancer gracefully offering aarti with candles or lamps in both hands and dancing rhythmically on a brass plate.

Batu Nrutya or Sthai

After the opening invocation or mangalacharan, the recital continues with batu nritya, the most difficult number of the style, which presents the entire gamut of the Orissi nritta technique. The dancer begins in the chowka position in slow tempo and, through a series of intricate movements, gathers momentum.

This dance contains all the basic elements of the Odissi dance technique and is considered essentially a part of the first year course

in a young dancer's training. A dancer who can perform batu nrutya or sthai correctly is equipped to learn any other nritta or pure dance item.

Batu nrutya is presented as an offering to Shiva in his form as Bhairav and is thus an acknowledgement of the pre-bhakti Shaivaite development of the dance historically. The opening phrases show the dancer playing musical instruments as devotional offerings. Playing the veena, percussion, mridang, flute and small cymbals, the dancer continues to sketch the dancer as preparing and offering dance in the temple. The top tier on the sculptures at the Konarak temple have larger than life-images of dancers playing these musical instruments and the development of the dance reflects the resonance and reference of life practice to sculpture.

Batu nritya is a unique pure dance composition that reflects the early tantrism of Orissa, which is still seen in Bhairav worship. Batuka Bhairav is one of the 64 terrific aspects of Shiva. Sthai is a pure dance, fundamentally similar to batu nrutya, and performed particularly by the disciples of Guru Deba Prasad Das.

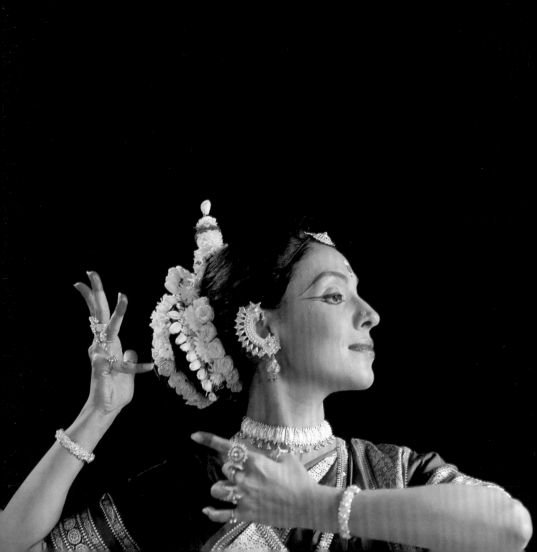

Pallavi

Pallavi is used as the descriptive term to describe all the pure dance items in the Odissi repertoire except for batu nritya/sthai and mokshya, and are generally named after the melodic line, or raga, to which they are composed. The structure, complexity and length of pallavis can vary considerably. Pallavi is a lyrical, pure dance composition that is often compared to the blossoming leaves on a tree, a poetic description for a dance structure that establishes a movement theme, a melodic or raga theme or a rhythmic or tala theme and then develops these themes in variations. Pallavis are sometimes composed with interpretations of a short text at the beginning, which expresses an emotional theme developed in the pure dance of the pallavi. If a pallavi begins with a Sanskrit shloka, it will be a description of the image or personified deity of the raga and is the only interpretive portion in the pallavi. When executed in slow tempo, it is likened to the illustration of the alap, but it may be performed in medium or fast tempo as well.

While a pallavi is a pure dance or nritta composition because it is not performed to a text, it is certainly not expressionless from a world

dance perspective. The feeling of a pallavi will be a basic mood that reflects the internalised experience of the pure dance movement and raga, or melody theme. This is usually joyous but may also express the shy anticipation of a young maiden preparing to meet her beloved, as in Shrungara pallavi set to Saveri raga, or conveying the feeling of waves on the sea as in Taranga pallavi set to Bilahari raga. A pallavi can be composed in one rhythmic structure or several, but the tempo gradually increases towards the climax of the dance, unlike Bharatanatyam, which maintains an even tempo throughout and increases speed by doubling or tripling the rhythm.

Depending on the length of the entire stage performance, there may be one, two or even three pallavis interspersed between dances for interpreting texts. A wide range of pure dance compositions has been choreographed under the umbrella of pallavi. Sequentially, after a pure dance establishes the technique and form of the Odissi style, the next developmental stage of a performance is typically to present the most important aspect of classical Indian dance—abhinaya or dramatic expression.

Abhinaya

Once a dancer's performance has established the Odissi context of body movements, eyes, head, neck, hands, and feet moving in rhythm and space, the dancer is prepared to move on to the most important element of the Odissi performance, abhinaya or dramatic expression. As abhinaya is performed to a song or gita, it is sometimes called gitabhinaya or sabhinaya as it combines sahitya or text, and abhinaya or expression.

The most predominant themes revolve around the story of Krishna and Radha. The emotion of love (shringar rasa) is most prevalent in the poetry from Jayadeva's Gita Govinda and closely followed by the devotional poetry of Oriya medieval saint/poet/song-writers like Banamali Das, Upendra Bhanja, Kavi Surya Baladeva, or Gopala Krishna Pattanaik.

Classical Indian aesthetics use human love (shringar rasa) as the closest metaphor to approaching an understanding of divine love, and consequently divides and subdivides the nuances and states of love in relation to anticipation, preparation, yearning, waiting,

disappointment, betrayal, reconciliation and ultimately, union. This aesthetic philosophy of love is presented to a highly sophisticated and refined degree in the aesthetics of Odissi dance and the poetry that inspires it.

Bhakti or devotion is the next most prevalent rasa or essential flavour projected through the dance. Yet, every other emotion may also be found in the repertoire and poetry used today for dance choreography extends to other epics, other gods and, as Odissi dance has grown across regional and linguistic borders, to other languages.

Sancharis are wonderful elements of expressive dance. A dancer does not merely mime the literal meaning of the danced text, but expands and elaborates on the meanings: Literal or abstract, connotative or denotative, subtly metaphysical or evocatively human. This is effectively accomplished through sancharis, the elaboration of one line or thought through any number of repetitions of a line while the dancer interprets it afresh each time to even create a mini story

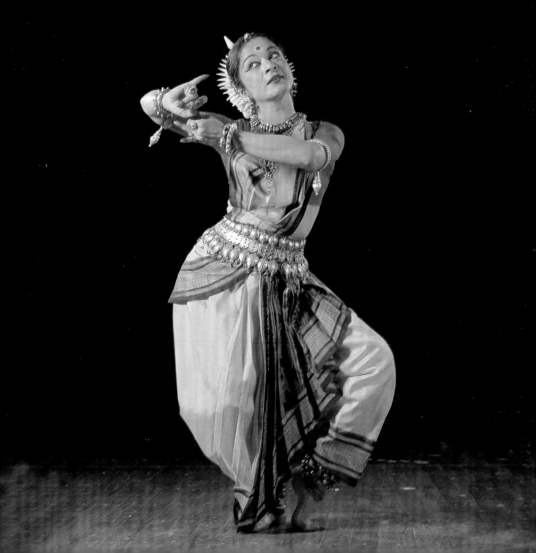

episode based on one line. Typically, a dancer might not use an entire poem in a choreography as the sancharis could stretch the singing of individual lines for some minutes or even half an hour, depending on the imagination and skill of the dancer to maintain a dramatic expression based on a line or stanza. The literary composition to which the dance is performed is mostly Vaishnavite, depicting man's yearning for the Supreme Being. The sakhi-bhava of the later Bhakti cult is evident. For those believing in sakhi-bhava, trained men as dancers dressed as women to perform in front of the gods. While the predominant focus of dramatic expression is on themes related to devotion to Krishna, recent years have seen a considerable expansion of texts used. These range from Shaivaite (Shiva based) and Shakti (female power of the universe) content, to historical and modern social themes.

Mokshya

Mokshya refers to the ultimate aim of life in Hindu philosophy, which is release from the cycle of birth and re birth and attaining union with the ultimate reality. While this may seem an over ambitious goal of

a dance composition, it reflects the culminating aspirations of the spiritual import of the performance. The dancer aims to create a transformational experience for him or herself and for the audience through the transformational intention of this spiritually based art. The concluding pure dance mokshya is the culmination of this aim by the artiste for this particular occasion in time and space. Mokshya is performed in a fast tempo, accompanied by the bols or mnemonic syllables of the pakhawaj. There is no music accompanying mokshya but the rhythmic variations can become quite complicated in the longer versions of mokshya. Mokshya is frequently concluded with a Sanskrit shloka.

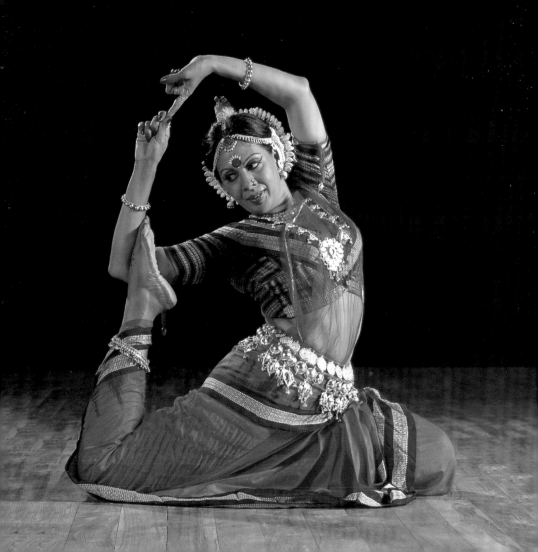

Sahitya

The poetic text, or Sahitya, is interpreted through the abhinaya, or dramatic expression of the dancer. The root of abhinaya means 'to lead towards' and this superlative dimension of all Indian classical dance genres is a distinctive aspect of the art which leads the audience to an experience of the essence of the poetry through dance. Primarily medieval Oriya compositions and the 12th Century Geeta Govinda are the base of Odissi dance Sahitya.

Jayadeva's Gita Govinda provides the core of the expressional dances of Odissi, as these were the only songs permitted in the Jagannath

Puri temple. Jayadeva earned sainthood for himself with the lyrical, religious eroticism of his poetry that is interpreted in classical dances from Kerala to Manipur. The ascetic, wandering life of this brahmin poet and Sankritist ended when a brahmin of Puri convinced Jayadeva that Jagannath himself had ordained his marriage to the brahmin's daughter Padmavati, dedicated to the temple as a dancing girl. The Gita Govinda was composed in the latter half of the 12th century by the poet, and performed in the temple by Padmavati.

Legend has it that Jayadeva hesitated to write the couplets in which Krishna asks Radha to put her foot on his head in apology for her distress, after she realises he has delayed coming to their tryst because of a dalliance with another gopi, expressed in the ashtapadi 'Yahi Madhava'. When Jayadeva took a break to bathe before lunch before returning to the difficult passage, Krishna himself appeared in Jayadeva's form, wrote the lines, Priye Charusheele, and ate the lunch prepared by Padmavati. When Javadeva found his wife claiming to have already served him and found the passage written, he understood that Krishna had divinely

blessed his poetic interpretation of the devoted relationship between Radha and Krishna.

As a dramatic, lyrical poem, Gita Govinda expanded on the classical genres of Sanskrit literature to appeal to a more diverse audience with religious, erotic and aesthetic meanings in a cycle of 24 songs. Poetic verses between songs give the song a context or reinforce the atmosphere with rich ideas and descriptions. The raga, or melodic pattern, for each song is indicated in the Gita Govinda manuscripts—generally 11 different ragas for the 24 songs, though there is no consensus on how these names relate to raga notation in later times. Medieval poetry and songs in Oriya are the second strand of texts used for Odissi abhinaya. The passionate, populist devotional fervour of the Bhakti movement inspired an enormous body of work in the local language in the 15th-16th century. Themes, style of expression and use of talas and ragas continue and develop in a clear lineage from those of the Gita Govinda. A popular format, the chautisa, was to use the 34 consecutive consonants to start each couplet or stanza of a poem.

Upendra Bhanja was a pioneer and leader in the ornate genre of mainly secular songs on human desire, such as 'Molli Mala Shyamaku Debi'.

I'll give Shyam a jasmine garland to satisfy mind and heart
I will apply sandalwood paste to allay the summer humidity
And wipe the beads of perspiration.
.... If he is good to me, I will do puja to him.
Poet Upendra Bhanja says he is a beautiful jewel
　　At whose Feet I meditate.

Gopalkrishna Patnaik's poetry takes the village girl, Radha beyond the ego of a charming young maiden in love to become the allegory of a genuinely metaphysical love for her Lord Krishna. Dancers and singers love the charm and simplicity of his poems that convey the spiritual dimensions of this love story.

Banamali was not a court composer like Kavisurya Baladeva Rath and Gopalkrishna Patnaik, in fact he renounced the world to live as a

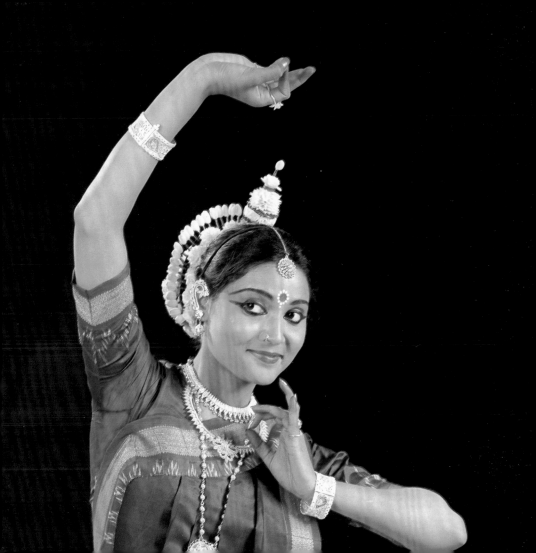

Vaishnavite sanyasi. His passionate devotion comes through his potent compositions.

Another poet deserving special mention is Salabega. He has a unique place in the pantheon of medieval Vaisnavite devotional poetry, as he was a Muslim devotee who prayed and sang outside the Jagganath Temple at Puri. One of his most moving compositions performed by dancers is Ahe Nila Sahila, oh Blue Mountain.

On the Radha-Krishna theme, which predominates Oriya musical poetry, three composer-poets particularly stand out—Kavisurya Baladeva Rath, Gopalkrishna Patnaik and Banamali Das. According to Mayadhar Mansinha, Kavisurya is considered the most musical, Gopalkrishna the most poetic and Banamali the most devotional. Kavisurya or 'sun among poets', is the title conferred on Baladeva Rath (A.D. 1789-1845) by one of the many contemporary Rajas who generously supported his richly musical, romantic poetry. Many of his songs have been collected in a 600-page book, but his truly celebrated work is a collection of 34 songs, the Kishorechanddrananda Champu.

Named for a patron Raja in south Orissa, Champu is a form that tested poet-composers of the time. The format elaborates the love of Radha and Krishna in songs that start with consecutive letters of the alphabet starting from ka.

As in other parts of the country, creative literature continued to inspire the dance form and provided the theme for the dance. As the Shaivite tradition gradually gave way to the Vaishnavite tradition in the state, the writings of Gajapati Emperour Kapilendra, the songs of Upendrabhaj in addition to the compositions of other Bhakti cult writers made tremendous contribution to the dance literature. These compositions have continued to be an inspiration for composers of the form till the early 20th century.

Other manuscripts from the province are as interesting for their general adherence to the Natya Shastra pattern as for their significant departures. There are a few notable manuscripts like the Sangita Narayana Nritya Khanda by Narayan Dev Gajapati of the 15th century, Nritya Kaumudi and Natya Manorama by Raghunath Rath,

Abhinayachandrika of Mahesvara Mohapatra and the Abhinaya Darpana of Jadunath Sinha of the 17th century. These are positive indications of the popularity and prevalence of the art form. Even after the 18th century, commentaries continued to be written and the form enjoyed great prestige within the temple.

Costume and Make-up

Odissi dance, like the other classical dance genres of India, gives great importance to the costume, ornamentation and make-up used in the performance. The classical texts refer to four essential forms of expression in the dance, namely body movement or angika, vocal and sung textual expression or vachika, pure communicative expression or sattvika, and the expression through costume, make-up and ornaments, aharya. Every classical and folk dance form of India reflects the regional character of its performing arts in the local traditions of textile and ornamentation used for the dance. Odissi is no exception. The beautifully woven silk saris of Orissa, its silver filigree ornaments and pith flowers, are the trademark accompaniments to the dance of Orissa.

Maharis who danced in the temple, typically wore black velvet bodices with the sari wrapped from the waist down. When Odissi began to be presented upon the stage, the sari was first wrapped as a dhoti to form a divided pyjama, with the decorative end-design of the sari, or pallu, spread in front. Over the years, various styles of tailoring the sari into the costume were developed. In one such design, the decorative end of the sari or pallu is pleated and snapped on to the costume so that it fans out as the dancer sits in chouka or square position. A fabric is fastened around the hips from behind, which defines the hipline.

In this costume, the blouse is made from the same sari material as is the cloth draping the front of the dancer. Various artistes have incorporated several variations on the length or angle of the front fan in the design, but the main distinction is a vertically draped front or the knee-to-knee fanned-out cloth. The woven sari used for a costume can be from any of the many wonderful traditional styles of the state, especially Sambalpur, Berhampur, and Cuttack. While the resplendent Sambhalpur silk ikats are known for their intricate weaving technique and subtle colour combinations, the Cuttack colours are more

contrasting. The Behrampur silks are known for their narrow rudraksha borders and stunning combinations. Another style that found favour with many dancers were the Bomkai sarees with their long and delicately woven pallus, which could easily be converted into the fan in the front. The fabric used for costumes on stage is mostly pure silk, though in some cases dancers do opt for baafta, a mixture of cotton and silk and pure cotton as well. In the rehearsal and practice situation, salwars or churidar pajamas with a half saree reaching just below the knee are the norm.

Many costumes include the unique single and double ikat tie-dyed and woven patterns of Orissa which travelled to Southeast Asia from here. Rudraksha bead designs date back to the Harappan civilisation and are a frequently found motif on Orissa saris, as are the conch shells and fish, among many other designs. Inspired by nature, these designs have several auspicious and ritual significance. There are kalashs, or the ritual pitcher, temple gopurams complete with the flag, conch shells and several types of fish, which are considered positive energy symbols. Some dancers have also used costumes with the Gita Govinda ashtpadis woven into them. These sarees are

not easily available but need to be woven specifically, for they are used only for the deities in the Puri temple.

Ornamentation

Odissi classical dance is unique among other classical traditions of India in its use of silver ornaments. The Maharis, and Odissi dancers through the 1960s, sometimes used gold ornaments near the face and on the hands, though the three-tiered silver belt has been in use much longer. Today, Odissi dancers, all use silver from head to waist. The dancer wears a silver tika in the parting of her hair, often with decorative silver chains running from the forehead tika till the ears. The back of the hair bun may have a large silver filigree pin or even a crescent silver wreath over the central pin. Earrings rise over the entire ear in peacock or geometric designs with large dangling bell-shaped jhumkas. The dancer may wear two to four necklaces and may have silver armbands, wide filigreed bangles and, perhaps, rings on every finger. The silver work comes from the unique tradition of Cuttack filigree in Cuttack district of Orissa. In a delicate style, popular far beyond its state borders, it has become part of several Southeast traditions as well. The belt or mekhala draped from the waist is

usually made with circular silver discs strung together in three lines. The jewellery is inspired from the detailed representations on the temples as well as medieval Oriya texts. The Oriya Mahabharata, written by Sarla Das in the 15th century, gives a detailed description of Prince Arjuna dressed as Bruhannari during his year disguised as a dance teacher. Everything from the indigenous silk sari to the bangles and bells, are described in the text.

Abhinaya Chandrika, the Sanskrit text specifically on Oriya dance, delineates in great detail the make-up, costume and ornaments of the dancer. It specifies a brightly coloured nine-yard sari, generally in red or green made of indigenous silk, a brightly coloured, bejewelled kanchula or tight-fitting blouse, the apron of frills skirting the hips and draping in front, called nibiandha, and a belt with tassels tied at the waist, called ajhoba. This quite accurately describes the costume worn by the maharis at the Jagannath temple in Puri but the costume worn by the Odissi dancer on the stage today is closer to that worn by the gotipuas or young male dancers who had been performing outside the temple over the last few 100 years. Many of the ornaments described in the Abhinaya Chandrika continue to be used

in the dance as well as in daily life. A dancer can certainly use fewer ornaments than mentioned in the text.

Hair Styles

Among all the elaborate hair designs seen on the temple sculptures of Orissa and described in Abhinaya Chandrika, the most commonly used style is a kind of hair-knot at the back of the head with a pushpuchuda. Pulling the hair back and tying it at the back of the head, then pulling the hair through, around, and over a large ring to give fullness to the shape, creates the beautiful hairstyle. This is occasionally combined with a braid of hair plaited down the back, if the dancer chooses to follow the mahari tradition. The hair is well-secured to withstand the vigorous movements of the dancer during a performance. The art of carving shola pith has been used to create a unique stylisation of flowers for the elaborate hairdo of the Odissi dancer. The soft, white, inner stalk of the shola pith, which grows throughout Orissa and Bengal, inspires a unique regional craft. The Odissi dancer wears shola pith flowers around her hair-bun and it is topped with a tiara of shola pith flowers representing the spire of Jagannath temple.

Make-up

The make-up developed over the last half a century emphasizes classical images of feminine beauty. The eyebrows should arch, and even curve up at the ends, to resemble the bow from which the 'God of Love' shoots his arrows. The eyes are outlined with black kajal (kohl) extended far beyond the corners of the eye to resemble a fish with a tail. The red bindi or kumkum on the forehead is surrounded by white painted designs, representing the sun and moon, or a flower. The hair-curl, spiraling on the cheek in front of the ear, is also standard in Odissi make-up for the stage. Alta, a red natural dye, outlining the feet and on the palms of the hands and fingertips, completes the make-up. The alta on the feet is used by women in eastern India on auspicious occasions and is considered to make the feet look like lotus flowers. It also serves to articulate the foot movement for the viewing audience.

The designs drawn are bold, as the consistency of the alta is like water, and it doesn't lend itself so easily to very detailed painting on the hands and feet. Besides, the idea is to attract the audiences' attention to the dancers' hand and foot movement.

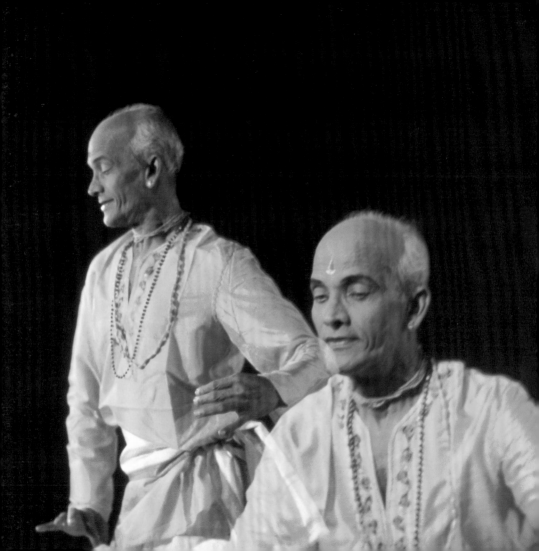

Technique

The dance of Orissa, like many other Indian and Asian forms, is very grounded, connected to the earth, with a low centre of body gravity, unlike Western classical dance that lifts away from the earth as much as possible, both in basic standing positions as well as elevations from the ground. Odissi essentially makes use of the head, eye, neck, hand and foot-contact techniques described in the Natya Shastra. It is the stylistic emphasis as well as the use of elements unique to Odissi that give it a totally distinctive character. The identifying importance of the sensual 'S' curve of the body in Odissi, created by the asymmetrical tribhangi position, can be seen

in sculptures dating back to the dancing girl of Mohenjodaro. The lyrical shift of torso during dance phases as well as in final sculpturesque poses is a defining characteristic of the Odissi style of movement.

Odissi is also a cultural and kinetic bridge between the geometrically etched dances extending south of Orissa and the lyricism and flow of dance in east India extending towards Southeast Asia. Put simply, the footwork may be precisely matching the percussion of the pakhawaj, while the upper torso liltingly continues to shift throughout a rhythmic phrase.

The gurus of today were trained by learning dance and dance phrases directly after completing some preliminary exercises. They have developed their own pedagogy for training their students based on the oral tradition of practice and Sanskrit and Oriya texts. This is an ongoing, developmental process as gurus continue to redefine the teaching of the basic technique. The Odissi Research Centre in Bhubaneswar, under the direction of Kum Kum Mohanty, has taken up a challenging task to define and codify actual techniques of Odissi

practice into a modern, published shastra, the Odissi Pathfinder I and II. A great deal of effort and collaboration is going into this process and it remains to be seen how widespread the new classifications used will be.

Bhangis — Positions of the Body

- Sama Bhanga
- Abhanga
- Chauk
- Tribanga

The basic positions of the body in Odissi (bhangis), include:
Sama bhanga is a straight position, a universal standing position with the feet together and parallel. Abhanga is an asymmetrical position, with the body weight shifted to either side and one hip consequently dropped lower and the upper body slightly bent to compensate. Picture a teenage girl standing with one knee slightly bent, weight onto one hip and perhaps, a hand on her waist. Two body positions define the special character of Odissi dance and its silhouette is symmetrical (chauk) as well as asymmetrical (tribanga).

Chauk is a symmetrical position with a deep, low centre of gravity, the bent legs turned out from the hips as wide as possible. Wider than the Bharatanatyam ardhamandali, lower than the Western ballet demi-seconde, chauk is square and strong. The traditional distance between the feet is the measure of both hands, joined thumb to thumb and extended to the little fingers, touching the heels while some gurus use the slightly narrower measure of one foot. Variations on the chauk range from the wider stance, mandala, to a less physically demanding ardha chauk (half chauk), that is becoming popular as a replacement for chauk by some dancers in recent years. The chauk position mirrors the square image of Jagannath.

Tribanga is the triple-bent, elaborately graceful position of the body. The head, shoulders, torso and waist, hips and knees zigzag back and forth across the centre of gravity to create a balanced asymmetry. Body weight is shifted onto the hip of one bent, supporting leg with the other leg slightly in front, turned out with its knee bent. The torso shifts directly towards the side of the front leg, with a deep curve in the waist, while the shoulder remains lined up in a plumb line over the hip. The head inclines, with the chin and top of the

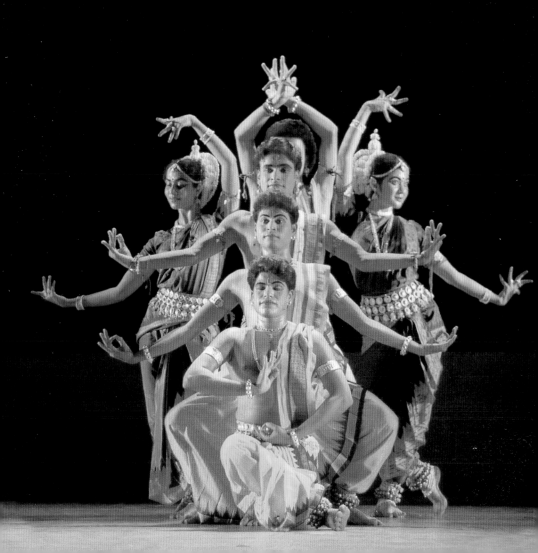

head shifting equally to opposite sides, from the top of the cervical spine.

Chala — Torso Movement

The movement of the torso in Odissi dance is one of its most distinctive features. The graceful shifting of the torso throughout a dance phrase gives a lyrical, softening effect to the movement, while the feet precisely match the rhythm accents. This torso shift does not displace the hips or shoulders from the plumb line of the body's centre of gravity. The hips remain steady as the torso shifts, while the shoulders reflect the movement of the torso by gently lowering on the side of the torso that contracts and rises slightly on the side to which the torso shifts. However, the shoulders neither go sideward with the torso, nor move independently up and down, which would create an exaggerated effect.

- Dakshyachala — shift right
- Bamachala — shift left
- Utchala — shift forward
- Prustha chala — shift backward

Pada Bhedas — Positions of the Feet

The four mentioned in the Abhinaya Chandrika are:

- Stambhapada — straight pillar step (feet parallel together).
- Mahapada — or great step (one foot raised, turned out, to rest across the supporting leg's knee).
- Dhanupada — or bow step (one foot across the turned out standing leg, weight on the ball of the foot and the sole of the foot facing the side wall directly).
- Kumbhapada — or pitcher step (heels raised and touching, knees bent turned out sideward, creating a diamond or pitcher shape between the knees and an open triangle between the floor and the heels.

Oriya texts and traditional practice have variations, additions and alternative names. Nearly 30 years ago, in addition to the four mentioned in Abhinaya Chandrika, six more foot positions were taught:

- Ekapada — one foot step.
- Lolitapada — knees bent and turned out, with one raised foot almost touching the opposite knee.

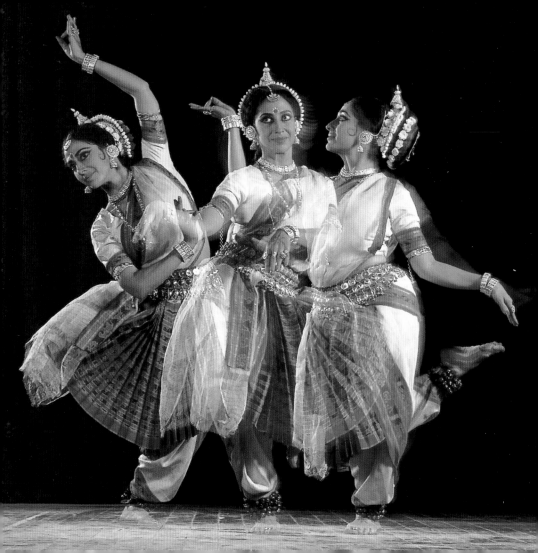

- Nupurapada — one raised foot almost touching the ankle while knees are turned out sideward.
- Asrita/suchipada — toe or ball of the foot pointed down and touching the floor at a right angle to arch of the other foot, a few inches away.
- Trasyapada — both feet turned out, flat on the floor, one foot a few inches out from the arch of the other.
- Rekhapada — feet parallel, heel to toe on either side of an imaginary dividing line.

Many more positions are actually used as part of the dance practice. The Odissi Research Centre, Bhubaneswar has codified a more inclusive list with input from several gurus to define and create names: Addipada; Yugmapada; Biparitamukhapada; Kumbhapada; Dhanupada; Prussthadhanupada; Mahapada; Ekkapada; Meena Puchapada; Anukunchita; Bilagna Parsnipada; Agra Bilangna Parsnipada; Tribhangapada; Swastikapada; Mandalapada; Choukapada; Ardha Chouka; Bandhanipada; Utparshnepada; Ardhaswastikapada; Rekhapada; Lolitapada; Uttolitapada; Ullolitapada; Nupurapada; Suchipada; and Kunchitapada.

Bhumis — Paths of movement using the stage space

Eight Bhumis are followed in Odissi that are mentioned in Abhinaya Chandrika:

Sama; Visama; Padma; Trikonaka also called Minadandi; Swastika; Chakra popularly called Ghera; Vartula; and Chaturasra.

Charis — Movements of the Feet

The core Charis in Odissi, said to be from the Abhinaya Darpana of Nandikeswara are:

Chalana; Chakraman; Sarana; Begini; Kuttana; Luthita; Visama or Vishansama.

Other Charis used in Odissi and quoted in the Abhinaya Chandrika from Sangeeta Ratnakara are Ratha Chakra, Paravrutta, Syandita, Marala, Karihasta, Urubeni, Katara, Mruga Trasa, Ardha-Mandalika, Sthitabarta. Charis that move into the air are called Akashiki charis.

Bhaunri (Bhramari) — Turns

Bhaunri is the Oriya term for the more familiar Sanskrit term for a turn, Bhramari.

Ekapada, Chakra, Kunchita, and Anga Bhramari are found described in the text of Nandikeswar's Abhinaya Darpana.

Ekapada Chouka Bhramari — The most frequently used turn in Odissi is performed in Chouka position lifting one foot to Lolitapada and turning smoothly clockwise or anti-clockwise with out any change in the body level.

Chakra Bhramari — Turning in Chouka with repeated stamps of one foot while one foot remains as a fulcrum.

Kunchita — Turning in place by stamping the front foot while back foot remains in Prusthadhanu.

Anga Bhramari — Rotating of the whole upper body.

Other traditional Odissi turns are Tribhangapada, Kumbapada, Dhanupada, Kumbapada, Prusthadhanu and Begini.

Uthas/ Utplabana — Jumps

Utpavanas is the Sanskrit term for elevations and jumps called Utha or Utplabana in Oriya.

Four mentioned in Nandikeswar's Abhinaya Darpana:

Alaga Utplabana — From chauk, raise one leg and jump on to it traveling to the side while lifting the other foot and bringing it down to chauk.

Krupalaga Utplabana — Jump on one foot from Samapada raising the other foot back to touch the buttocks behind.

Motita Utplabana — From Samapada, lift the right foot and jump onto it to the right and bring the left foot behind to Prusthadhanu Paada and repeat to the left, completing jumps to both sides.

Ashwa Utplabana — From Samapada, raise one foot and take a small jump forward raising the other foot and bringing it down to Samapada.

From Odissi tradition and named through seminars at the Odissi Research Centre:

Chouka Utplabana — Jump in chauk in place, front, back or either side without raising the body vertically.

Chouka Ekpada Utplabana — Jump in chauk, jump again onto one leg, and lower the other.

Bhedas — Head, Neck, Eye Movements

Movements of the head (sira bheda), neck (griba bheda), and eyes (sristi bheda), generally follow the Shastric enumerations of the Abhinaya Darpana and Natya Shastra, though usage and frequency will vary significantly, according to tradition and choreography of various gurus. An important point to notice in the usage of griba bheda, or neck movements, would be that the side-to-side movement of the neck (sunarischa) is used when the body weight is absolutely symmetrical, as in the chauk position or moving in the typically Odissi heels-up movement, called beginni. Asymmetrical movements in tribanga, or out of chauk, will have neck movements like tiraschina and tathaibh paribartita that tilt chin and head while maintaining a 'space hold' on the nose and the top of cervical spine, directly behind it. The effect of the head movement over the shifting torso is similar to the Andhra clay dancing dolls with each body part on a pivot point above the next, shifting back and forth over the centre of gravity.

Mudras or Hasta Abhinaya — Hand positions

The Oriya terminology for single and combined hand positions from

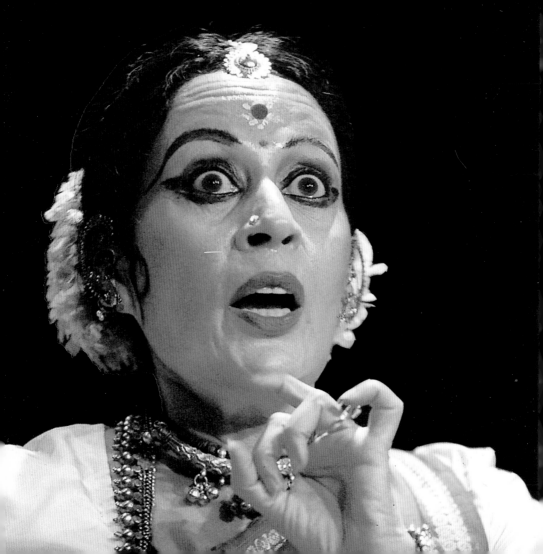

the medieval Oriya text, Abhinaya Chandrika was transposed into the equivalent Sanskrit terminology from Natya Shastra and Abhinaya Darpana to help convince the post-Independence cultural czars of Delhi and Madras that Odissi merited the status of an independent classical style. It is interesting to note the similarities and differences in the Oriya and Sanskrit terminology:

Abhinaya Chandrika (Oriya)	Natya Shastra (Sanskrit)	Abhinaya Darpana (Sanskrit)
Dhvaja	Pataka	Pataka
Dhyana	Arala	Arala
Ankusha	Kapitha	Kapitha
Bhaya	Mukula	Mukula
Ardhachandra	Ardhachandra	Ardhachandra
Aratrika	Shikhara	Shikhara
Kshipta	Alapadma	Alapadma
Nirdeshika		Suchimukha
Hansa Pakshya	Mrigasirsha	Mrigasirsha
Gomukha		Simhamukha
Mrigakshya		Hamsasya

Orissi	Kathakali
Danda	Kapitha
Tambula	Arala
Bardhamanaka (Lalata)	Bardhamanaka

Other Abhinaya Darpana hand positions are also used in Odissi.

Besides hand positions/gestures shared between Odissi and other texts and styles, there are a number specific to Odissi. The finest work on defining these has been by Tara Michael, a French dancer/scholar. Of course, the meaning of any particular single or joined hand positions is not limited to that suggested by its name and the first named usage. Like alphabet letters that depend on the words and phrases made, the Viniyoga, or usage of the hand gestures, communicates through the combined context of all the expressive elements:

Traditional Odissi variations of single hand gestures — Asamyukta Nasta Abhinaya

Anda — the stick, staff or sceptre; Ankusa — the elephant goad; Sarpa-Sirsa — the serpent head; Vastra — clothes; Dhyana —

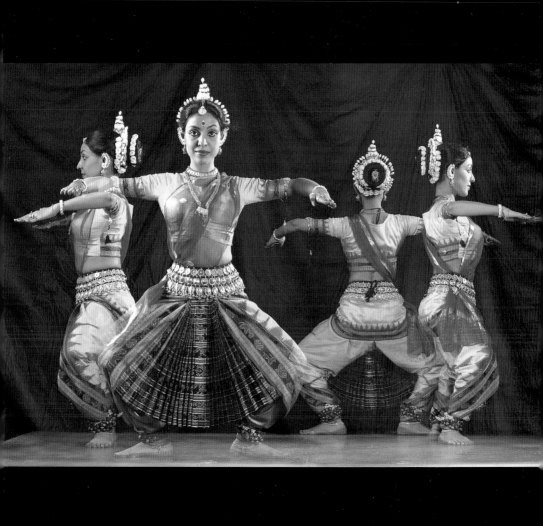

meditation; Vardhamana — progression; Prabodhika — the awakening one; Suci — The needle; Puspa — the flower; Tambula — the quid of betel; Bhramara — the bee; Vyaghra — the tiger; Man Bana — the arrow; Dhanus — the bow; Venu — the flute.

Traditional Oriya double handed gestures: Samyukta Hasta Abhinaya
Padma — the flower; Gabakshya — the window; Mayur — the peacock; Ubhaya-Kartari — the double arrow-shaft; Pradeepa — the small oil lamp.

Music

Odissi music stands at the crossroads of Hindustani (North Indian) music and Carnatic (South Indian) music, with a strong regional identity that some Oriya scholars and artistes have made efforts to have accepted as a third school of Indian music. The musical tradition dates back 10 centuries and there are several treatises written between the 16th and 18th century that attest to its classicalism, if not proving a uniquely separate identity from the other classical music traditions of India. Some ragas and taalas mentioned in the Oriya texts are no longer known, though identifying them would help establish the separate identity for Oriya classical music that Odissi dance only achieved in 1956. Odissi vocal music for dance as well as concert is certainly known for its unique

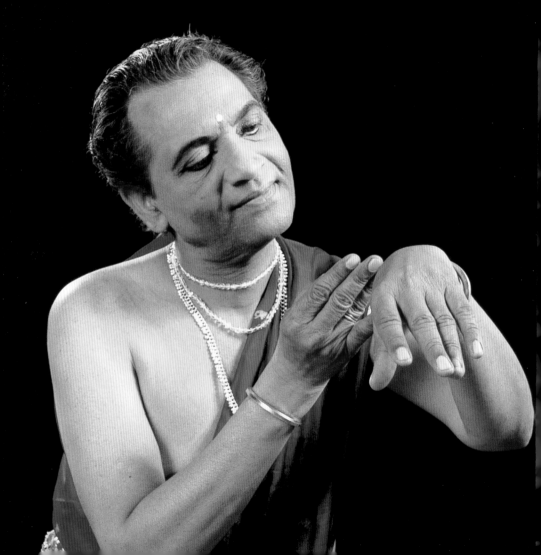

gamakyas (ornamentation patterns) and chands (syncopated rhythms).

Melodious modes are used from both north and south India. Ananda Bhairabi, Mukhari, Hamsadhwani and Shankara Bharanam are examples of ragas used in Odissi music from the Carnatic (South Indian) tradition. Hindustani ragas like Chandrakauns and Malkauns are used, and many ragas are known by Oriya names.

Rhythmic support to the dance is provided by the pakhawaj (known as mardola in Orissa) and, to a lesser degree, by the gini, or small cymbals which maintain the laya or tempo. A few terms used in Oriya percussion are particularly relevant to the dance:

Ukutas (bol or bani)
The percussionist will often play and speak the ukutas (bol or bani), which are the mnemonic sounds that mimic the individual sounds of the strokes on the pakhawaj. (Every Indian percussion instrument will have different variations of the sound of the open and closed strokes on the particular drum heads, and so the spoken syllables will also be different).

Maana (Tihai in Hindustani terminology)
Triple repeating pattern to end a musical or dance sequence.

Chanda
Syncopated rhythmic structure, especially the start of the ukuta or bol, and dance-step based on it, after leaving the first beat of the tala empty.

Arasa
A sequence of ukutas composed of difference chandas that finish with a tihai (maana in Odissi) in which there may be any khandis or gadis.

Khandi
A short (dance) phrase/sequence, generally less than one or two avartan (cycle of the matras or beats of a particular tala) which does not start on sum (the concluding beat of a taala which falls on the count of 'one'). A khandi may or may not be or have a tihai.

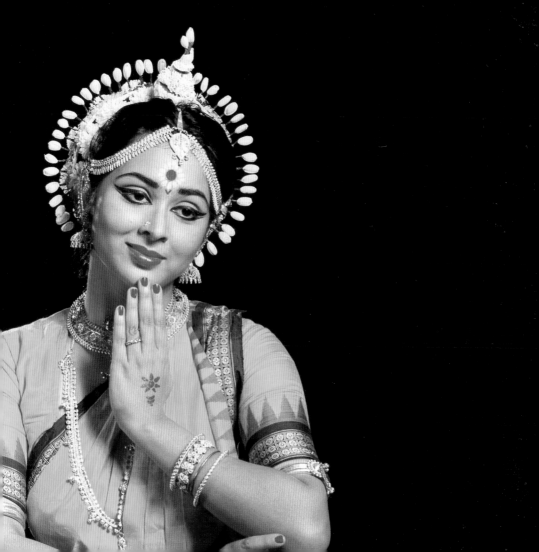

Gadi

A short rolling sequence of bols without rest, 4.6.8 or more (matras or beats), in an aesthetic rhythmic construct (example: terekita dhini) with a matra that can be repeated.

Dance Orchestra

Odissi dance requires percussion, to be played on a pakhawaj, a vocalist, and one or more melodious instruments, usually a flute, violin, sitar or veena. In addition to these three essential musical components, gini or small cymbals is important, though the player does not have the status of the Bharatanatyam natturvanar, who plays the cymbals and conducts the dance orchestra. Ukutas or bols are spoken by the pakhawaji or the gini player (particularly if the gini player is the non-pakhawaj-playing dance guru).

Odissi Today and Tomorrow

The challenges facing traditional performing arts are considerable. Nonetheless, art forms like Odissi fulfill aesthetic and metaphysical needs on multiple levels that will continue to exist, irrespective of how fast paced life becomes. There is some concern on whether classical dance forms like Odissi will still have a place in the new century. Some of the issues and challenges include the potential dilution of tradition by innovation and fusion, the effects of institutional learning vs the guru-shishya parampara (teacher-student transmission lineage), the waning interest and attention spans of audiences raised on television and information technology, and problems of patronage and professionalism in a market driven

economy. The survival of classical dance in India has probably not been so endangered since the Victorian British passed their anti-nautch laws, yet, to use a well known quotation: News of my death has been greatly exaggerated. Dance traditions are organic: Living, growing and changing to reflect the society in which we live and to serve aesthetic, intellectual, emotional and spiritual needs. Change must be both artistically sound and should sensitively reflect essential shifts in society rather than superficial or commercial pressures for novelty.

Odissi has successfully transitioned to the concert stage from the inner sanctums of temples. Now there are the challenges to adjust to new contexts, including television and even Internet-based media. Experiments in theme, choreography, and even venue will produce a variety of results, some ill conceived and some that are aesthetically sound. As new texts, themes and collaborations become more sophisticated in integral ways, they may find a permanent place in the repertoire. The spread of Odissi outside Orissa naturally inspires many artistes to explore new texts and languages. An invocation to the deity of a particular site of performance, and even in the local

language, is an expansion rather than a breaking of tradition. Many dancers experiment on choreographing to non-traditional texts, or using fusion of forms and non-traditional musical instruments. While these explorations are not always successful, they may eventually strengthen the organic growth of the tradition. Despite the antiquity of classical dance in India, they can all be considered neo-classical owing to the revival and reconstruction of most of them in the early 20th century.

Issues related to training, nurturing and professional career viability for the dancer are perhaps more serious challenges than ways that the classical dance repertoires will develop in the new era. First, dance training of artistes through the ideal of the guru-shishya parampara is virtually a thing of the past. This one-to-one teaching over a length of time, in an atmosphere free of distractions, ideally allowed the teacher to totally control the student's development. Now, imbibing the teacher's knowledge and attitude towards life, philosophy and the performing arts is reduced to primarily technical dance practice, unless the guru trains his or her own child. Even gurus teaching their own children have to contend with the demands

of school and other interests competing for the child's focus.

In the ideal institutional learning situation, students should be able to depend on developing their art in a situation where the techniques, theory, performance practice and related areas of music, philosophy, language, history and fundamentals of the art are structured into a curriculum and taught by master teachers in each subject. This should create an atmosphere where the best training is imparted to enough students to maintain the traditions and obtain exposure and interaction with others to foster a personal sense of aesthetics, compatible with tradition and creativity.

Unfortunately, this ideal institutional model doesn't exist. The potential faults of a guru-shishya parampara have too often been brought into the institutions: Lack of responsibility for nurturing the artiste, selfish withholding of expertise for personal reasons, disregard of commitments of time and effort in scheduled classes. Without the benefits of learning under a parental, dedicated master teacher or a committed pedagogy of an institution, the prospect of quality artistes that can hold the audience are dim. In fact, looking at the solo

performers of Odissi, Kuchipudi and Bharatanatyam, one generally sees senior artistes and a vast population of fledgling young artistes who soon disappear without developing into a middle level range of professional artistes.

Young dancers come to the stage without the involvement and depth of training needed to provide a solo performance that can hold an audience for hours. This results in a chicken or egg situation where the audiences find traditional solo dance performances quaintly charming and rather boring after a short time of enjoying the youth and energy of the artiste. Past practices included introducing a young artiste to performance at puja or temple programmes, then to discerning rasikas, and finally to a wider public. Young artistes do work hard, but perhaps appear on the stage with more public relations than is warranted and the confused audience finds that the art is lacking, rather than the artiste. This is where group dance choreography and new themes become the most viable solution for interesting performances by dancers trained within modern constraints.

Picture captions

Cover Durga Charan Das Ranbir's troupe in group composition
Page 3 Author Sharon Lowen
Page 10 Guru Kelucharan Mohapatra who was instrumental in the revival of Odissi
Page 13 Soaring to perfection: Late Sanjukta Panigrahi
Page 24 Reela Hota is working on tantric philosophy of kundalini
Page 29 Gotipua - boy dressed as girl in an acrobatic posture
Page 32 A mahari, a temple dancer
Page 37 Multi-image of Kumkum Das performing Ashtapadi
Page 48 Madhavi Mudgal, one of the foremost disciples of Kelubabu
Page 53 Kiran Sehgal has perfected the tandava style of Mayadhar Raut
Page 56 Late Protima Bedi started Nrityagram near Bangalore
Page 61 Kavita Dwibedi daughter and disiple of Harekrishna Behra
Page 72 Late Guru Pankajcharan Das
Page 77 Guru Gangadhar Pradhan's troupe in a group composition
Page 80 Sharon Lowen in a montage of pure dance sequence of Pallavi
Page 86 Sonal Mansingh in the choreography Sunayana
Page 89 Madhavi Mudgal depicts a Chowk
Page 92 Guru Harekrishna Behra
Page 95 Sharmila Biswas who is working on the mahari tradition